Colour M
Wate
Julie Collins

Search Press

First published in 2015

Search Press Limited
Wellwood, North Farm Road,
Tunbridge Wells, Kent TN2 3DR

Reprinted 2016, 2018, 2019 (twice), 2021

ISBN: 978-1-78221-054-2

Acknowledgements
To Winsor & Newton for kindly
supplying the paints and other
materials used in this book.

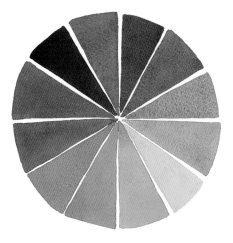

Contents

Introduction

Our lives are full of colour yet we rarely stop to think how important it is. In art, colour is one of the key ingredients of a successful painting. A harmonious colour arrangement is crucial. In this book I will give you a basic understanding of colour: how to understand the terminology, how to see colour, how to use it in context, and most importantly how to mix and combine colours. This will increase your joy of confidence in using watercolour.

During many years of teaching art, I have always found that students are inspired by learning basic colour mixing. Immediately they begin to see huge possibilities in their painting and are amazed that this can be achieved with a limited palette and a little knowledge. Indeed, if you want to be a successful painter, I believe you must learn colour mixing first and painting second. It is well worth investing time practising and making your own colour charts.

This book includes many colour charts, and can be used as a quick reference, but if you can invest some time, you can use it as a comprehensive guide to colour mixing. Practice really does make perfect and the more you practise, the more colour will become second nature and in turn you will then be able to paint more intuitively.

The book starts with primary, secondary and tertiary colours and the colour wheel. I will use only thirteen colours in total and show you how much you can create from them! We will look at complementary colours, warm and cool colours, dull and bright colours, colour tone and finally how to mix a huge variety of yellows, oranges, reds, pinks, violets, blues, greens, browns, blacks and greys from our palette of thirteen colours.

In watercolour painting, you are not only mixing colour but also adding water. This alters the tone of the mix and so affects the colour you are trying to make. It is important to bear this in mind as I have often seen beginners who are running out of a colour, and instead of remixing, they add water. The colour then becomes paler and is not the same as the original. This may sound obvious but it highlights how important it is to get the amount of pigment and water correct to achieve the colour you want. When mixing watercolour, it is also very important to remember that many colours dry up to 50% lighter than they look when wet.

I always advise spending plenty of time mixing and testing colours before committing them to the 'real' painting, just as an athlete warms up and doesn't just set off on a 100m sprint. This will save hours of frustration and disappointment.

Colour mixing is best approached with enjoyment as if you think of colour mixing as fun you will certainly have better results!

Opposite

This annotated painting was done using a limited palette of only three colours. It never ceases to amaze me how much colour you can create with only three colours and a few areas of white paper!

COLOURS
Winsor lemon (WL)
Permanent alizarin crimson (PAC)
Winsor blue red shade (WBRS)

MIXES
1. Turquoise green (dark): WBRS 90% + WL 10%
2. Turquoise green (medium): WBRS 90% + WL 10%
3. Turquoise green (light): WBRS 90% + WL 10%
4. Bright green: WBRS 50% + WL 50%
5. Lime green: WL 90% + WBRS 10%
6. Orange: PAC 50% + WL 50%
7. Yellow orange: WL 80% + PAC 20%
8. Yellow (dark): WL 100%
9. Pale yellow WL 100% (a very watery mix)
10. Red (dark): PAC 100%
11. Red (medium): PAC 100%
12. Pink: PAC 100% made with lots of water
13. Dark grey (almost black): equal amounts of WBRS + WL + PAC
14. Mid grey: equal amounts of WBRS + WL + PAC
15. Very light grey: equal amounts of WBRS + WL + PAC – a very watery mix
16. White: the paper

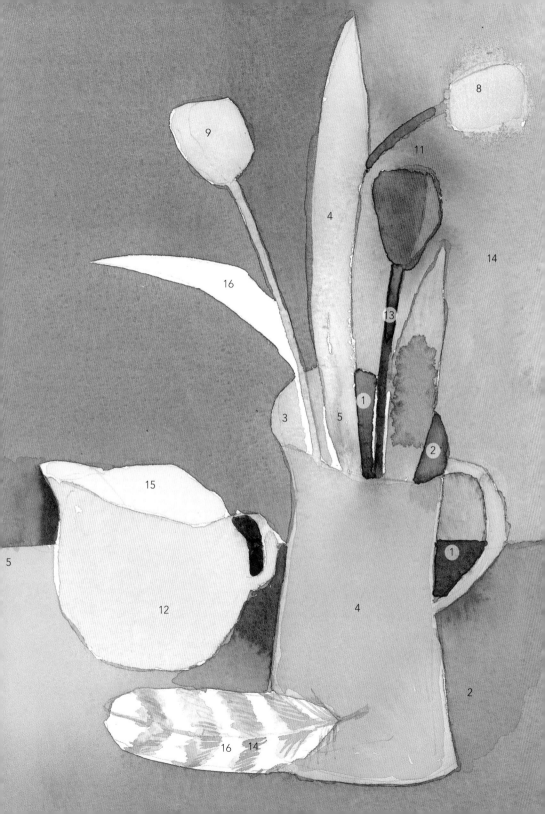

Materials

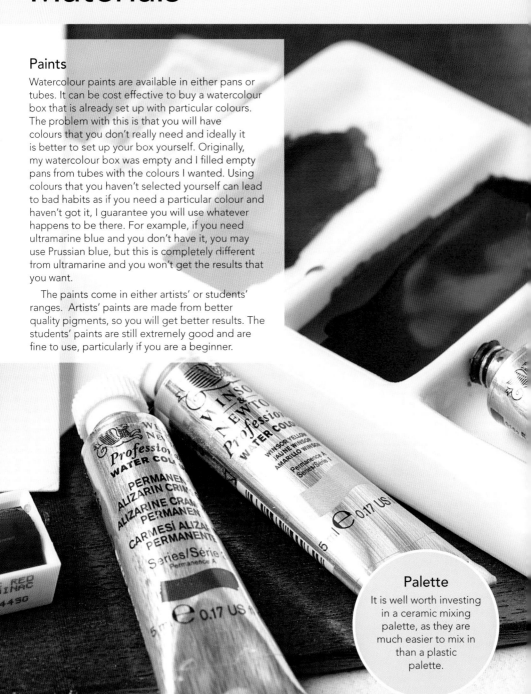

Paints

Watercolour paints are available in either pans or tubes. It can be cost effective to buy a watercolour box that is already set up with particular colours. The problem with this is that you will have colours that you don't really need and ideally it is better to set up your box yourself. Originally, my watercolour box was empty and I filled empty pans from tubes with the colours I wanted. Using colours that you haven't selected yourself can lead to bad habits as if you need a particular colour and haven't got it, I guarantee you will use whatever happens to be there. For example, if you need ultramarine blue and you don't have it, you may use Prussian blue, but this is completely different from ultramarine and you won't get the results that you want.

The paints come in either artists' or students' ranges. Artists' paints are made from better quality pigments, so you will get better results. The students' paints are still extremely good and are fine to use, particularly if you are a beginner.

Palette

It is well worth investing in a ceramic mixing palette, as they are much easier to mix in than a plastic palette.

Brushes

Please use your old brushes for mixing paint. An old synthetic brush about size 6 or 8 is just right for watercolour mixing. There is no need to wear out your best brushes, especially finest sable, for mixing paint!

If you make time to care for your brushes, they will last a lot longer. The worst thing you can do is to leave a brush standing in your water jar. This bad habit will ruin the point of your brush in no time and once the point has gone, you won't be able to paint well with it. Taking time to clean and store your brushes properly is also very important.

There are many choices of brush for watercolour, from synthetic to finest sable. As a general rule, you get what you pay for, and if you are a keen watercolourist, it is worth investing in good brushes. I use several types of brush for watercolour: a good make of synthetic brush, finest sable and also squirrel mops, but never any bristle brushes, as they will ruin your watercolour paper.

Paper

There is an enormous choice of paper available. When you are testing your colour mixes, do use watercolour paper as you won't see the colours and effects as well on cartridge paper.

Basic paper types include:

Rough – textured surface, good for landscape painting.

Not – medium texture surface, also good for landscape.

HP (Hot pressed) – smooth surface, good for flower painting and commonly used by botanical artists, as there is little texture to the paper.

It is worth remembering that all paper types will vary from manufacturer to manufacturer, for instance, Saunders Waterford HP will be different to Fabriano HP. Try as many papers as you can to see what you prefer.

Paper also comes in various weights including: (190gsm) 90lb, 300gsm (140lb) and 638gsm (300lb). Weights of 300gsm (140lb) and over are almost like cardboard and can be used unstretched, whereas lighter weights must be stretched properly before you use the paper, or it will cockle when wet.

Colours used in this book

There are only thirteen colours used in this book and they are briefly explained and illustrated here, going from dark to light.

Reds

Permanent alizarin crimson: a vivid red with a blue undertone. It is a highly transparent and staining colour and very useful in both flower and landscape painting.

Permanent rose: a bright rose violet. It is a transparent staining colour and essential in your palette for flower painting.

Winsor red: a warm mid-red with a slight orange undertone. It is transparent and also a staining colour. Very useful in flower painting and for mixing oranges and pinks.

Indian red: an opaque red with a blue undertone. Particularly useful in watercolour landscape painting and can be used to make subtle purples.

Burnt sienna: a rich brown pigment made by burning raw sienna. It is a transparent pigment with red-brown tones. The most useful colour in my palette, essential for landscapes and to make great greys.

Yellows

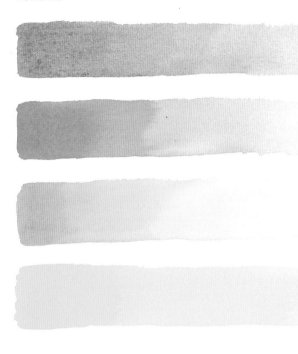

Raw sienna: a bright yellow-brown pigment. It is also transparent and essential in landscape painting. It granulates beautifully.

Cadmium orange: an opaque orange single pigment colour with a high tinting strength. It is an essential colour as it isn't possible to mix an orange like this.

New gamboge yellow: a warm mid-yellow pigment. It is a transparent colour and a very useful mid-yellow to include in your palette.

Winsor lemon: a very clear, bright yellow. It is transparent and also a staining colour and can be used to mix amazing lime greens.

Blues

Cobalt blue: a clean, fresh blue. It is a transparent colour and granulates beautifully on the paper. Very useful for painting skies and mixing greys.

French ultramarine: a rich transparent blue and the other most useful colour in my palette. Like cobalt blue, it granulates on the paper and is essential for landscapes, skies and mixing greys.

Winsor blue (red shade): a deep, intense blue with a red undertone. A transparent and very staining colour.

Winsor violet (dioxazine): a vivid mid-purple. When undiluted, it can be used as a deep black. A transparent, staining colour, essential for flower painting.

Colour

The colour wheel

The colour wheel is essential to understanding colour mixing and using colour. Making your own colour wheel will teach you how to mix tertiary colours quickly, and this will lead into the exciting world of colour mixing, so that you will no longer feel limited to primary colours.

1 Set up your palette and materials and then draw your template on to the watercolour paper.

2 First, paint the three primary colours – be careful to keep the tone of each colour as similar as possible and clean your brush thoroughly when you move on to a new colour. Paint yellow at 12 o'clock, red at 4 o'clock and blue at 8 o'clock.

3 Next, paint the three secondary colours: orange at 2 o'clock, violet at 6 o'clock and green at 10 o'clock.

4 Last, mix the six tertiary colours: yellow-orange at 1 o'clock, red-orange at 3 o'clock, red-violet at 5 o'clock, blue-violet at 7 o'clock, blue-green at 9 o'clock and yellow-green at 11 o'clock.

Materials

Paints:
 Winsor red
 Ultramarine blue
 New gamboge yellow

Palette

Round brushes sizes 6 & 2

A4 watercolour paper, Not surface, 300gsm (140lb) weight

Test paper

Two water jars

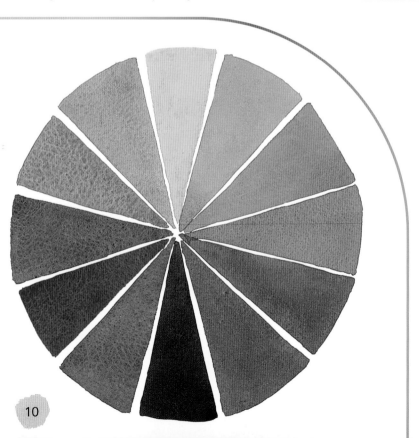

10

Note

Further information about the primary, secondary
and tertiary colours can be found on pages 12–15.

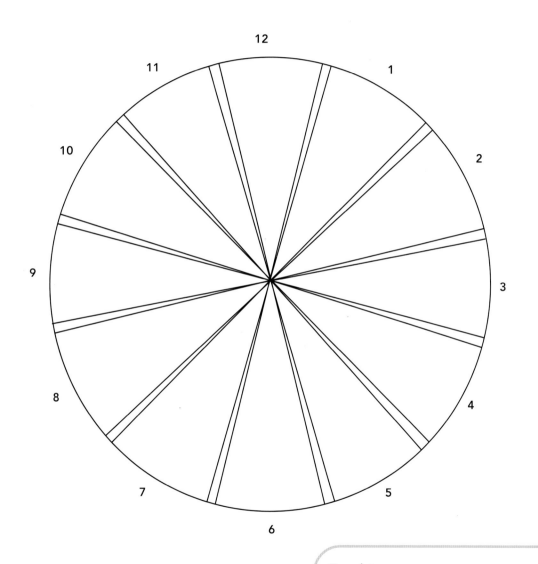

Template

Transfer this template on to watercolour
paper to create your own colour wheel.

Primary colours

There is a lot to be read about the theory of colour but for the purpose of this book, I want to keep it as accessible as possible. Red, yellow and blue are the primary colours and you can mix a useful set of colours from these. These are primaries because you must have them to start with, as you cannot mix them.

Here are swatches of the two reds, two blues and two yellows that are used in this book. Try making the exact tone of each primary colour swatch. This will be good practice for your colour mixing later on, as you will begin to think about tone and become aware of the amount of water you are adding from the word go.

Begin by noticing the difference between the two reds, yellows and blues.

Blues

French ultramarine

Cobalt blue

Reds

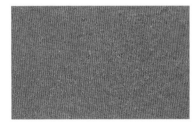

Winsor red

Permanent alizarin crimson

Yellows

Winsor lemon

New gamboge yellow

Secondary colours

Secondary colours are made from mixing one primary with another in equal amounts, eg, red and yellow = orange. This is fully illustrated here and can also be seen in context on the colour wheel.

Greens

French ultramarine + Winsor lemon

Cobalt blue + new gamboge yellow

Oranges

Winsor red + Winsor lemon

Permanent alizarin crimson + new gamboge yellow

Purples

Winsor red + French ultramarine

Permanent alizarin crimson + French ultramarine

Tertiary colours

Tertiary colours are created by mixing a primary colour with an adjacent secondary colour or by mixing two secondary colours together.

The tertiary colours are:

Red-violet, red-orange, yellow-orange, yellow-green, blue-violet and blue-green. The chart below and right illustrates two of each of the tertiary colours and explains the colours used in each mix.

Yellow-orange; Winsor lemon+ (Winsor lemon + Winsor red)

Red-orange: Winsor red + (Winsor red + Winsor lemon)

Red-violet: Winsor red + (Winsor red + cobalt blue)

Blue-violet: cobalt blue + (cobalt blue + Winsor red)

Blue-green: cobalt blue + (cobalt blue + Winsor lemon)

Yellow-green: Winsor lemon + (Winsor lemon + cobalt blue)

Yellow-orange: new gamboge yellow + (new gamboge yellow + Winsor red)

Red-orange: Winsor red + (Winsor red + new gamboge yellow)

Red-violet: Winsor red + (Winsor red + French ultramarine)

Blue-violet: French ultramarine + (French ultramarine + Winsor red)

Blue-green: French ultramarine + (French ultramarine + new gamboge yellow)

Yellow-green: new gamboge yellow + (new gamboge yellow + French ultramarine)

Complementary colours

When complementary colours are placed next to each other, they create the strongest contrast and enhance each other. The most common examples are:

Green with red Orange with blue Yellow with violet

The easiest way to see this is through examples, as painted below. Note how the cobalt blue reinforces an orange or, in other words, how they literally complement each other.

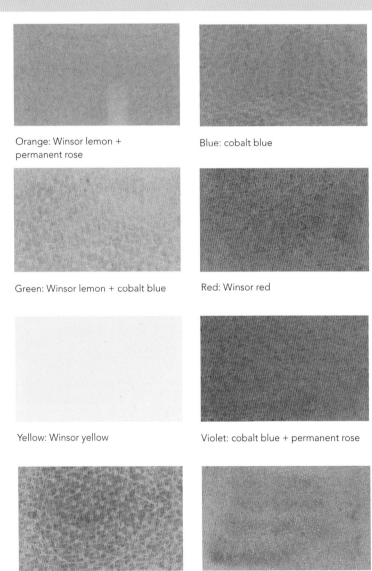

Orange: Winsor lemon + permanent rose

Blue: cobalt blue

Green: Winsor lemon + cobalt blue

Red: Winsor red

Yellow: Winsor yellow

Violet: cobalt blue + permanent rose

Green: Winsor lemon + French ultramarine

Brown: burnt sienna

You can dull down a colour by adding its complementary colour to your mix. Look at the examples here and then try experimenting by making the colours for yourself. For example, if you need to create a shadow colour for your orange, then add the complementary, blue, to your orange mix.

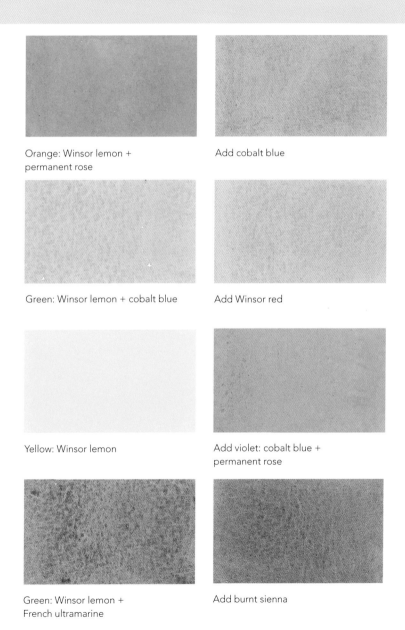

Orange: Winsor lemon + permanent rose

Add cobalt blue

Green: Winsor lemon + cobalt blue

Add Winsor red

Yellow: Winsor lemon

Add violet: cobalt blue + permanent rose

Green: Winsor lemon + French ultramarine

Add burnt sienna

Warm and cool colours

Warm colours include reds, oranges and yellows and cool colours include blues, violets and greens. However, when you consider colour more closely, there are also cool reds, cool yellows, warm blues and warm violets. See the chart below that gives you a few examples of this.

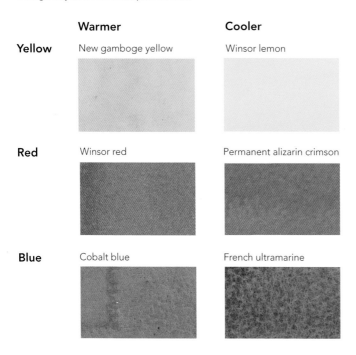

	Warmer	**Cooler**
Yellow	New gamboge yellow	Winsor lemon
Red	Winsor red	Permanent alizarin crimson
Blue	Cobalt blue	French ultramarine

90% of the main colour + 10% of another colour to dull it

When you need to dull or modify a colour such as a bright yellow like new gamboge, try adding 10% of a blue such as French ultramarine. This creates a much more subtle colour than if you use a paint straight from the tube.

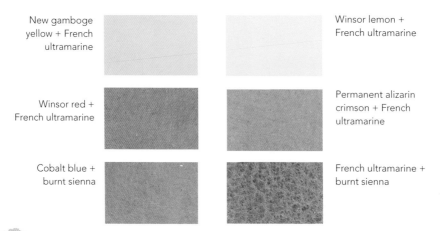

New gamboge yellow + French ultramarine

Winsor lemon + French ultramarine

Winsor red + French ultramarine

Permanent alizarin crimson + French ultramarine

Cobalt blue + burnt sienna

French ultramarine + burnt sienna

Creating depth in a painting

To create depth in a painting you must consider both tone and how warm or cool the colours are. Warm, bright colours will be used in the foreground of a painting, and as the painting recedes, the colours will be paler and slightly bluer (cooler.)

The easiest way to illustrate this is to look at the simple examples below. In order for the mountains in the distance to recede, they must be paler in tone and also bluer. See what happens when the distant mountains are painted darker and browner – they jump straight out at you.

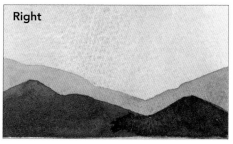

Right

Wrong

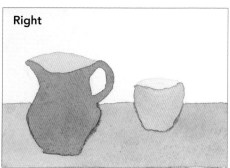

Right

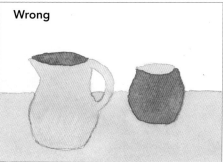

Wrong

Exercise

Try this simple exercise yourself and it will help reinforce how to create depth in your paintings.

Colours: cobalt blue, Indian red, burnt sienna and Winsor blue (red shade). Mixes: When you make these mixes, note the tone as well as the colours that are mixed together.

Cobalt blue + Indian red – **pale**

Cobalt blue + burnt sienna – **medium**

Winsor blue red shade + Indian red – **dark**

1 Apply a pale wash for the background.

2 When this is dry, add a medium wash for the mountains in the middle distance.

3 Again, when dry, add a dark wash for the foreground mountains.

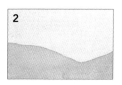

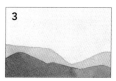

Colour tone

The tone in a painting is crucial to its success. To begin to assess tone accurately, make a 'tonal' colour wheel as shown below. This is not as easy as it looks but is an excellent exercise to help you understand tone.

Choose one colour; here I have used Winsor red. Start at 12 o'clock on your wheel and paint a very dark red (i.e. a lot of pigment and not too much water). Copy the tones that I have created here. At 1 o'clock, add a little water to lighten slightly and then more water at 2 o'clock and so on until you reach the final section, which will be very pale pink. The pale colours in watercolour appear light because the white of the paper shows through the transparency of the paint.

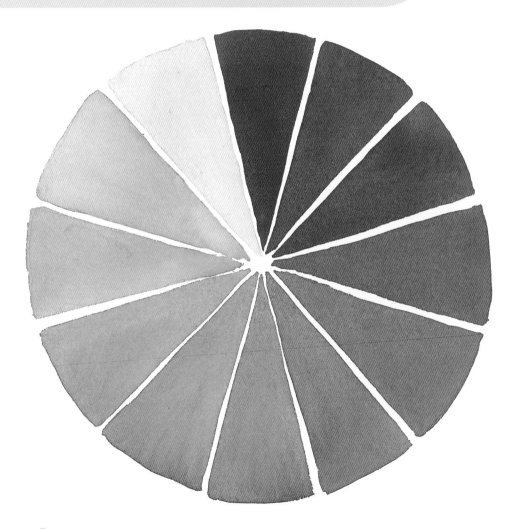

Try recreating the four tones of each of the colours shown below.

French ultramarine

French ultramarine and burnt sienna (50% of each)

Indian red

Indian red + French ultramarine (50% of each)

Permanent alizarin crimson

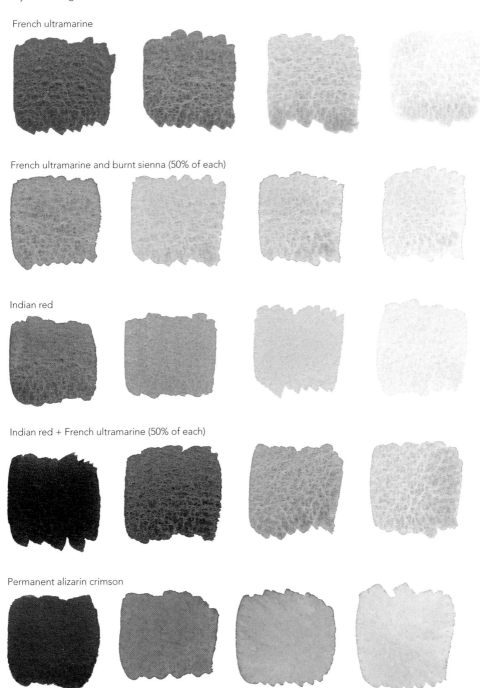

Using a limited palette

Painting with a limited palette has the advantage of creating harmony in your work. You will have to work harder to mix the colours that you need, but you will also learn a great deal about colour on the way! You will be amazed at how many colours you can create from only one red, one yellow and one blue. The charts below illustrate this, and they do not even include the tonal variations you have at your disposal.

Working with one red, one blue and one yellow, I have created charts which work as follows:

1 Pure colour
2 Colour + 10% of next colour
3 Colour + 20%
4 Colour + 30%
5 Colour + 40%

6 Colour + 50%
7 Colour + 60%
8 Colour + 70%
9 Colour + 80%
10 Pure colour

Winsor blue (red shade) + Indian red

Indian red + new gamboge yellow

French ultramarine + Indian red

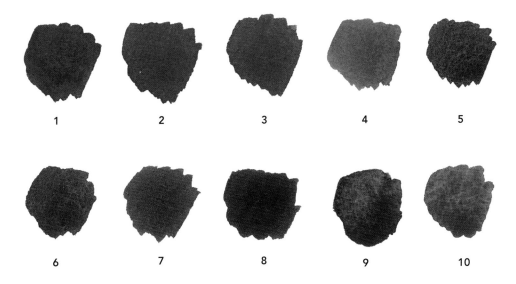

1 2 3 4 5

6 7 8 9 10

Winsor lemon + Indian red

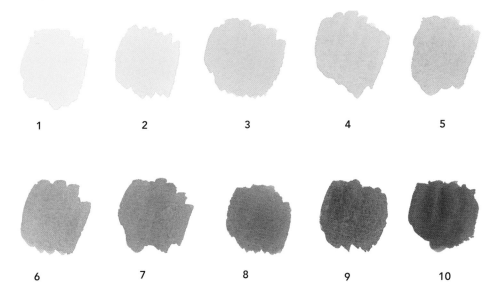

1 2 3 4 5

6 7 8 9 10

Winsor blue (red shade) + new gamboge yellow

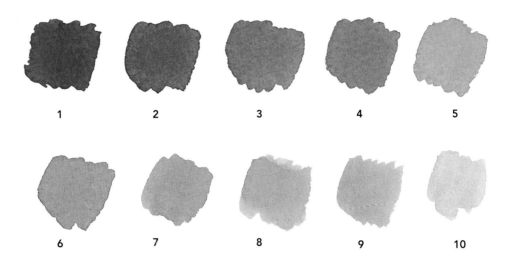

1 2 3 4 5

6 7 8 9 10

French ultramarine + Winsor lemon

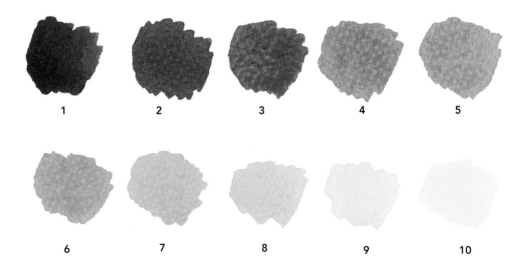

1 2 3 4 5

6 7 8 9 10

French ultramarine + Winsor red

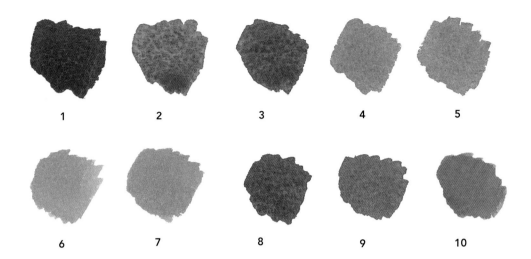

1 2 3 4 5

6 7 8 9 10

Winsor red + Winsor lemon

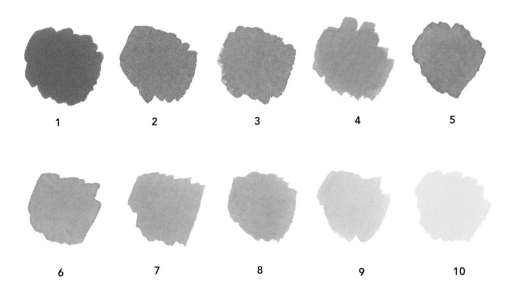

1 2 3 4 5

6 7 8 9 10

Dull and bright colours

When we refer to 'dull' colours, we really mean 'less bright'. When we refer to 'bright' colours, we must remember that the brightest colours are the pure pigments that come straight from the tube, and we can't make these colours any brighter. But we can dull them. We may be tempted to use black to dull down a colour, but black will deaden colours. It is better to darken a colour by adding the opposite colour in the spectrum, e.g. we can add blue or violet to yellow-green or yellow-orange mixtures. This will dull the colour as if it is in shadow, but it will still be colourful. See the examples below and then see if you can think of some of your own.

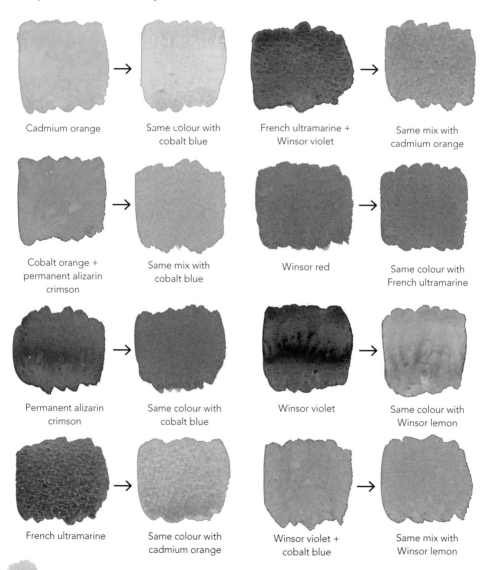

Cadmium orange	Same colour with cobalt blue	French ultramarine + Winsor violet	Same mix with cadmium orange
Cobalt orange + permanent alizarin crimson	Same mix with cobalt blue	Winsor red	Same colour with French ultramarine
Permanent alizarin crimson	Same colour with cobalt blue	Winsor violet	Same colour with Winsor lemon
French ultramarine	Same colour with cadmium orange	Winsor violet + cobalt blue	Same mix with Winsor lemon

Local colour

To make the most of the colours in your paintings you need to consider the relationships of the colours used. Notice in the simple examples below how a colour will appear to be completely different when placed next to another colour – it may appear brighter, lighter, darker or cooler depending where it is in your picture in relation to other colours.

Winsor lemon + French ultramarine with Winsor red

...with French ultramarine

...with cadmium orange

Winsor lemon + Winsor red with Winsor red

...with French ultramarine

...with cadmium orange

Indian red + French ultramarine with Winsor red

...with French ultramarine

...with cadmium orange

Permanent rose with Winsor lemon

...wth cobalt blue

...with cobalt blue and Indian red

Permanent alizarin crimson with Winsor lemon

...with cobalt blue

...with cobalt blue and Indian red

Medium French ultramarine surrounded by medium burnt sienna + French ultramarine

Pale French ultramarine surrounded by pale permanent rose

Winsor red surrounded by a mix of Winsor blue (red shade) + new gamboge yellow

Winsor lemon surrounded by a mix of Winsor blue (red shade) + permanent alizarin crimson

Cadmium orange surrounded by a mix of Winsor blue (red shade) + Winsor lemon

Cobalt blue surrounded by a mix of Winsor lemon and permanent rose

Colour mixes

The next part of this book is dedicated to colour mixing in the following format: start with one pure colour, then add 20% of another colour, then add 40%, then add 60%, lastly add 80%.

Yellows and oranges

Winsor lemon

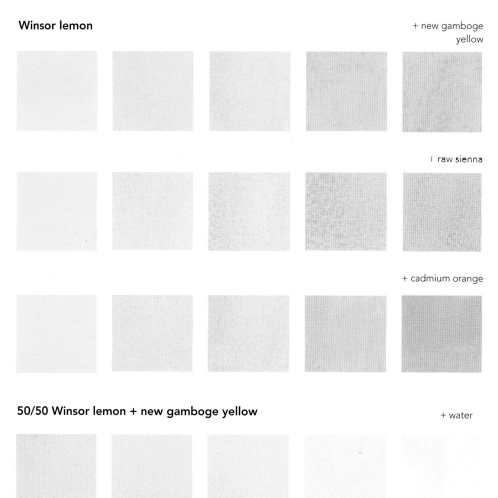

+ new gamboge yellow

I raw sienna

+ cadmium orange

50/50 Winsor lemon + new gamboge yellow

+ water

New gamboge yellow

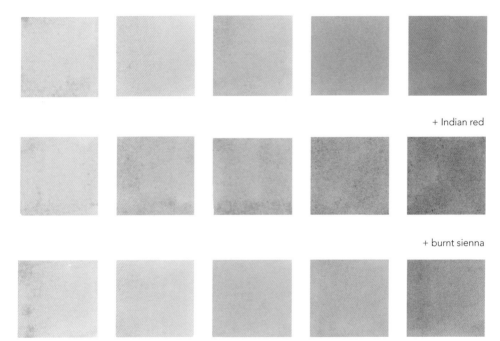

+ Indian red

+ burnt sienna

50/50 new gamboge yellow + burnt sienna

+ water

Raw sienna

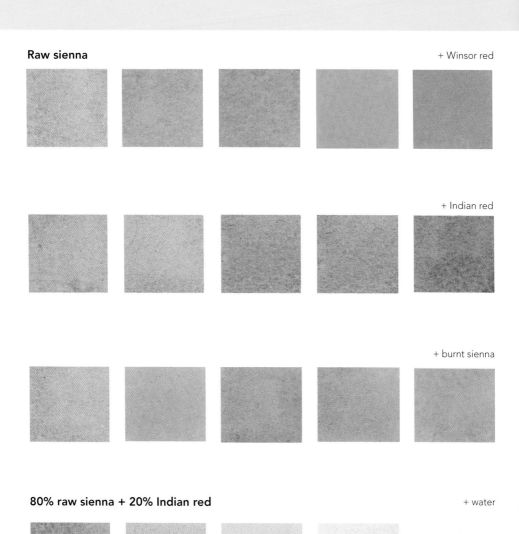

+ Indian red

+ burnt sienna

80% raw sienna + 20% Indian red + water

Cadmium orange

+ permanent alizarin crimson

+ Winsor red

50/50 cadmium orange + Winsor red

+ water

Reds and pinks

Winsor red 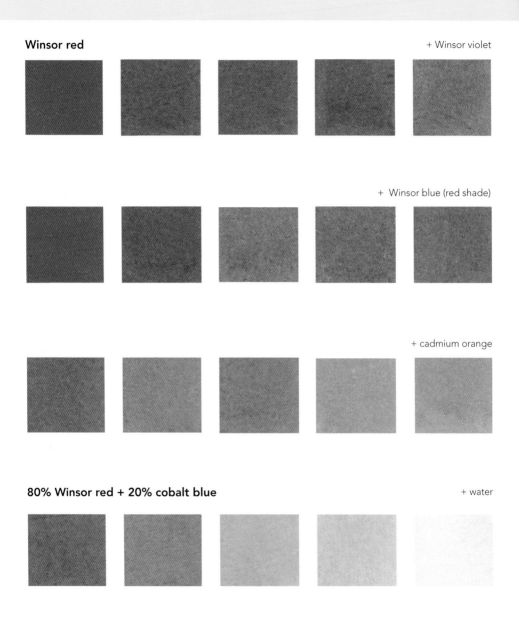 + Winsor violet

+ Winsor blue (red shade)

+ cadmium orange

80% Winsor red + 20% cobalt blue + water

Permanent rose

+ permanent alizarin crimson

+ cadmium orange

+ Winsor violet

50/50 permanent rose + Winsor violet

+ water

Permanent alizarin crimson

+ Winsor violet

+ French ultramarine

50/50 permanent alizarin crimson + French ultramarine

+ water

Indian red

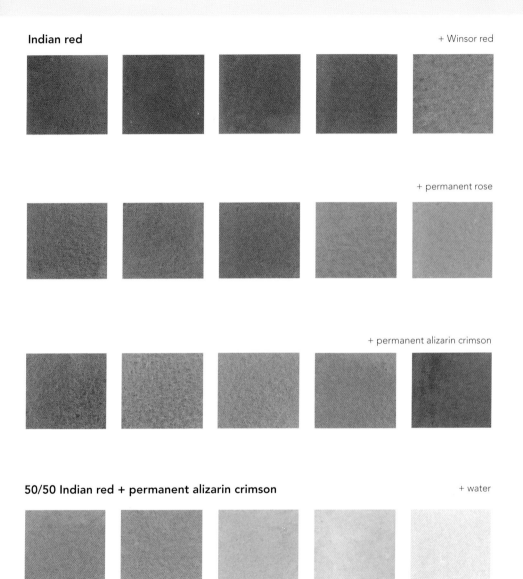

+ Winsor red

+ permanent rose

+ permanent alizarin crimson

50/50 Indian red + permanent alizarin crimson

+ water

Violets and blues

French ultramarine

+ cobalt blue

+ Winsor blue (red shade)

+ permanent alizarin crimson

50/50 cobalt blue + French ultramarine

+ water

Cobalt blue

+ permanent rose

+ Winsor red

50/50 cobalt blue + permanent rose

+ water

Winsor blue (red shade)

+ permanent alizarin crimson

+ permanent rose

+ Winsor red

80% Winsor blue (red shade) + 20% Winsor red

+ water

Winsor violet

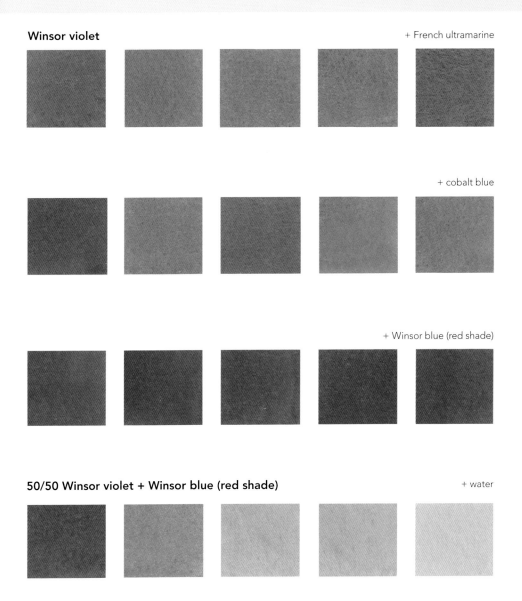

50/50 Winsor violet + Winsor blue (red shade)

+ water

Greens

French ultramarine

+ Winsor lemon

+ new gamboge yellow

+ raw sienna

20% French ultramarine + 80% Winsor lemon

+ water

Winsor blue (red shade)

+ Winsor lemon

+ new gamboge yellow

+ raw sienna

20% Winsor blue (red shade) + 80% Winsor lemon

+ water

Cobalt blue

+ new gamboge yellow

+ raw sienna

50/50 Winsor blue (red shade) + raw sienna

+ water

Tips on mixing greens

Try mixing as many greens as you can by using the blues and yellows in your watercolour box and not using any 'straight' greens. Here are various mixes, in shades from pale and medium to dark, to help you get started, but then experiment with other yellows and blues. I find this a great way to learn colour mixing.

Winsor blue (red shade) + raw sienna

Winsor blue (red shade) + new gamboge yellow

Cobalt blue + Winsor lemon

French ultramarine + Winsor lemon + burnt sienna

French ultramarine + new gamboge yellow

Cobalt blue + burnt sienna + Winsor lemon

Browns

Burnt sienna

+ Indian red

+ raw sienna

+ Winsor lemon

Indian red

+ new gamboge yellow

+ Winsor lemon

+ raw sienna

50/50 Indian red + raw sienna

+ water

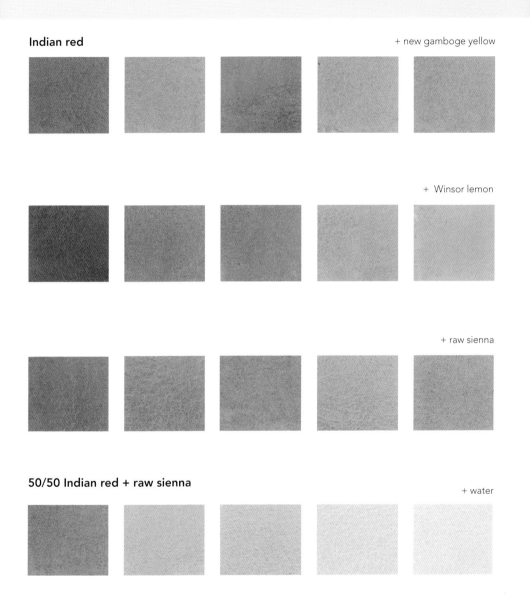

Burnt sienna + French ultramarine

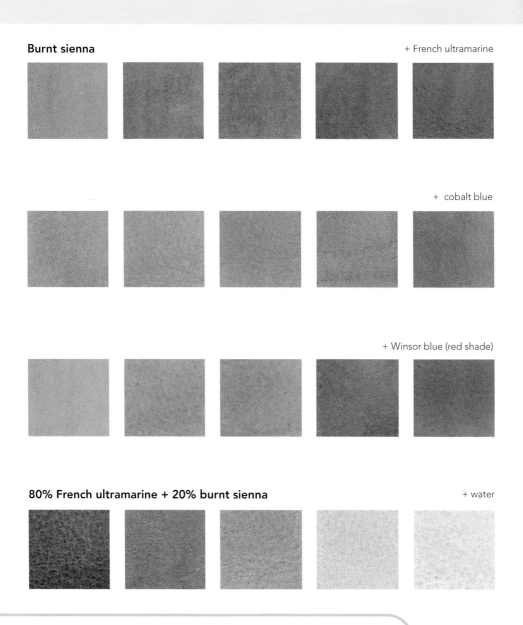

 + cobalt blue

 + Winsor blue (red shade)

80% French ultramarine + 20% burnt sienna + water

Tip
Try adding water in this way to all the blue and brown mixes to make pale greys.

Winsor blue (red shade)

 + burnt sienna + burnt sienna + + Indian red + Indian red +
 raw sienna raw sienna

French ultramarine

 + burnt sienna + burnt sienna + + Indian red + Indian red +
 raw sienna new gamboge
 yellow

Cobalt blue

 + burnt sienna + burnt sienna + + Indian red + Indian red +
 raw sienna new gamboge
 yellow

French ultramarine + burnt sienna + raw sienna + water

French ultramarine + Indian red + new gamboge yellow + water

Glossary

All these terms are explained in the context of watercolour painting.

Absorbency How quickly or how much water is absorbed into the paper.

Artists' range The highest quality paints, containing the purest pigments.

Bristle brush A coarse-textured brush made from bristle and not suitable for watercolour paint as it will damage the surface of the paper.

Cartridge paper A high quality paper used for drawing, but not suitable for watercolour painting.

Colour wheel A wheel shape including the three primary, three secondary and six tertiary colours (see page 10). Essential to understanding colour mixing.

Finest sable Top quality brushes made from sable; excellent for watercolour as they hold a great deal of paint and also have a good point.

Flat brush A brush with a flat or square end.

Fugitive A colour that is not permamnent and can fade away if exposed to daylight.

Granulating Colours that separate when mixed, giving a grainy, textured appearance.

HP Hot pressed, the method used to make this paper. It has a smooth surface and is often used by botanical artists who don't want any texture so that they can achieve fine detail.

Local colour How one colour affects another in a picture or particular context.

Not Not hot pressed – the method used to make this paper. It is cold pressed and has a medium texture between HP and Rough paper.

Opaque A more solid colour, where the paint does not allow the white of the paper to shine through.

Pans Solid paint that comes in a block. When wetted with a brush, it can be used in exactly the same way as tube paint.

Permanent A lightfast colour, for instance permanent alizarin crimson. The old alizarin crimson could fade in daylight.

Rough Rough paper has a textured surface that is very useful in landscape painting. Note that Rough paper varies greatly between one manufacturer and another.

Round brush A brush with a round shape and a point.

Squirrel mop A soft brush that holds a huge amount of paint but also has a very good point. Excellent for watercolour painting.

Staining This paint stains the paper (or clothes) easily, and cannot be removed.

Stretched Paper that is made taut by damping and taping round each side so that it remains completely flat and will not buckle when watercolour is applied.

Students' range Lower quality paints, but a good and more affordable range.

Synthetic brush Made from acrylic or synthetic material, suitable for watercolour painting.

Tone The shade of a colour; how light or dark it is.

Transparent A paint that you can see through, allowing the white of the paper to show through it.

Tubes Paint in a tube. Tubes keep the paint soft, but it will eventually harden when squeezed into a palette, in contact with air.

Unstretched Paper used without stretching, as above. Only heavier weight papers are suitable for using with watercolour without stretching.